Copyright 2011 Star-Art Coloring.
All rights reserved.

ISBN 978-1-257-86461-4

Introduction

While shopping one day my little sister and her friend bought some coloring books to pass the time. This might seem ordinary to you, but my sister is seventeen and her friend sixteen. I hadn't realized how much teens, not just toddlers, enjoyed coloring for fun.

I heard them say that it would be nice if there were coloring books for teens, something with more mature art and more details. Remembering how I had copied some of my art for them to color, I decided to make a coloring book for older kids. I wanted to create something with more complicated drawings and more challenge to the imagination than most children's coloring books had to offer. After settling on a theme, I set to work and this book was born.

My trademark for this theme is a fish hook. Each picture has a hook which may not be easily seen. Perhaps the enemy of sea life, but here laughed at as a memento by all the creatures. During the clean-up process my editor discovered a tiny hidden cross in one of the drawings. I liked this and felt it expressed my faith so she left it in and tried to spot one in each picture. Some had to be placed so she picked tricky places to put them. Have fun finding both objects, if you can. If you can't, I've included an answer sheet in the back. (I hate puzzles that don't have answers.)

I hope that no mater how old or young the artist, you will be able to enjoy this as much as I did making it. If this is a big hit (I really hope so), you'll see future projects with different themes. Have fun and get expressive with your coloring. I have many real plants and sea creatures in each drawing, so you might want to look them up for their proper color, but use your imagination. These beings are *pure* imagination so go wild and enjoy.

JeSeaKat

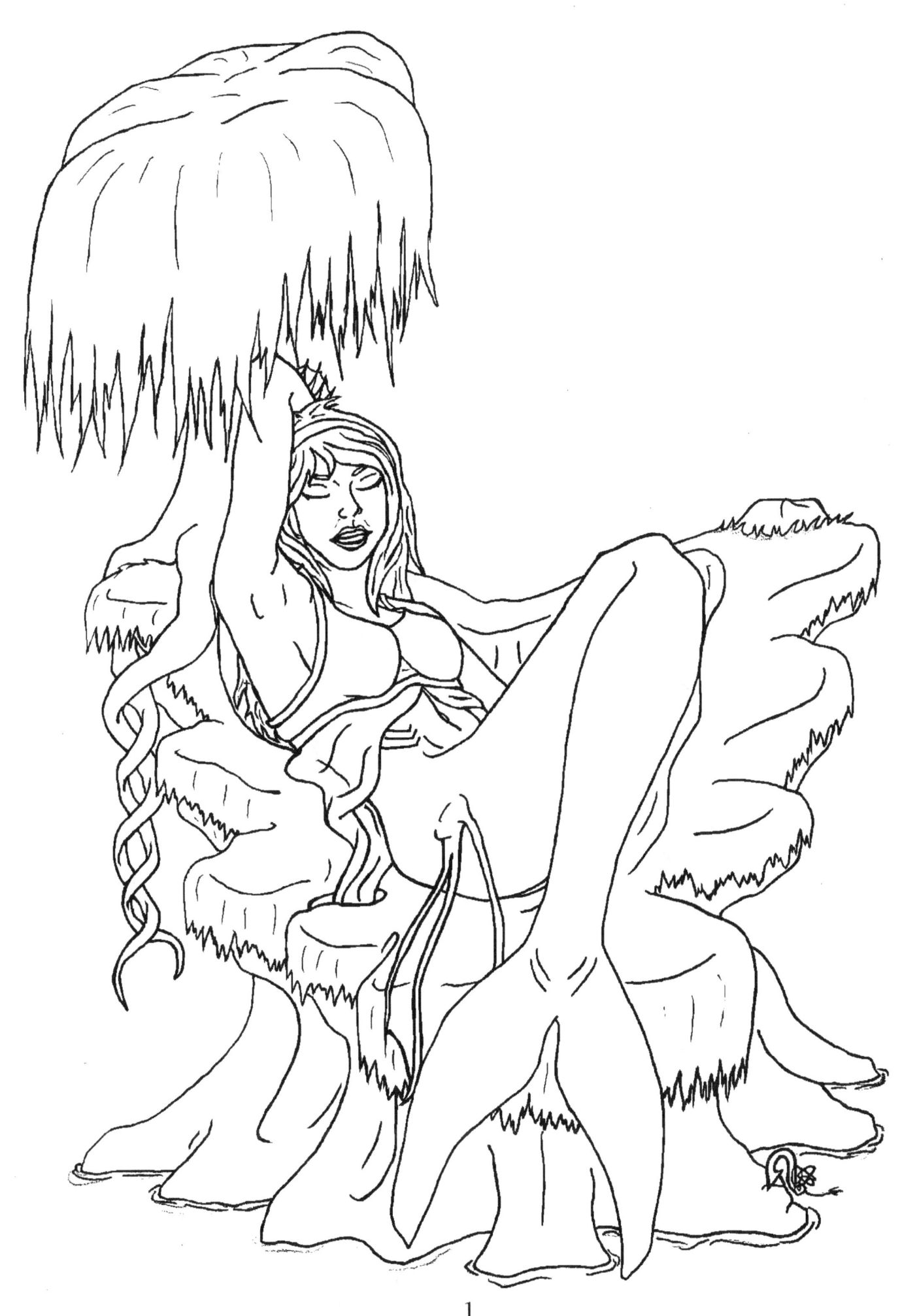

Illustration #1
SUNBATHING

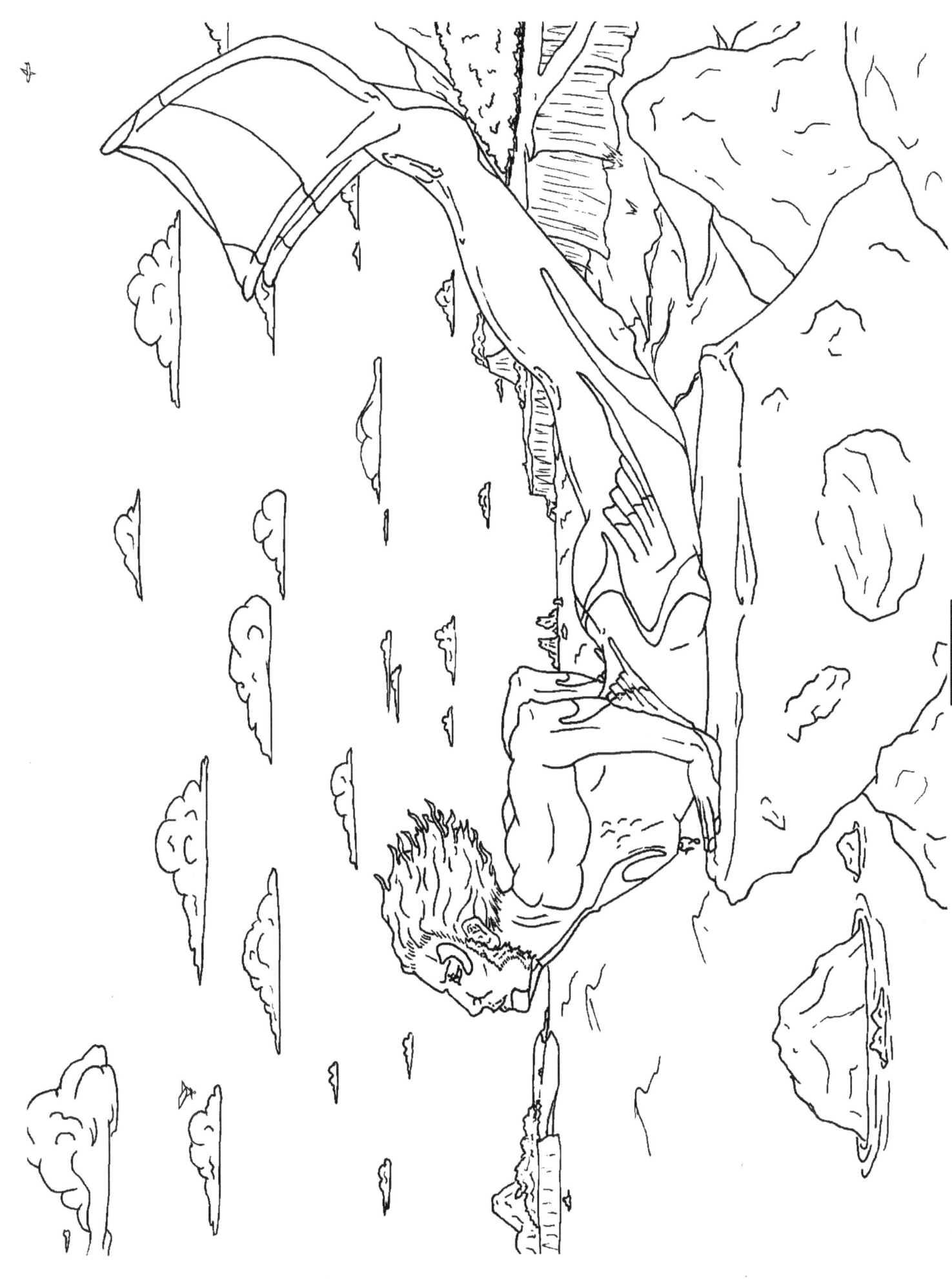

Illustration #2
SUNSURFER

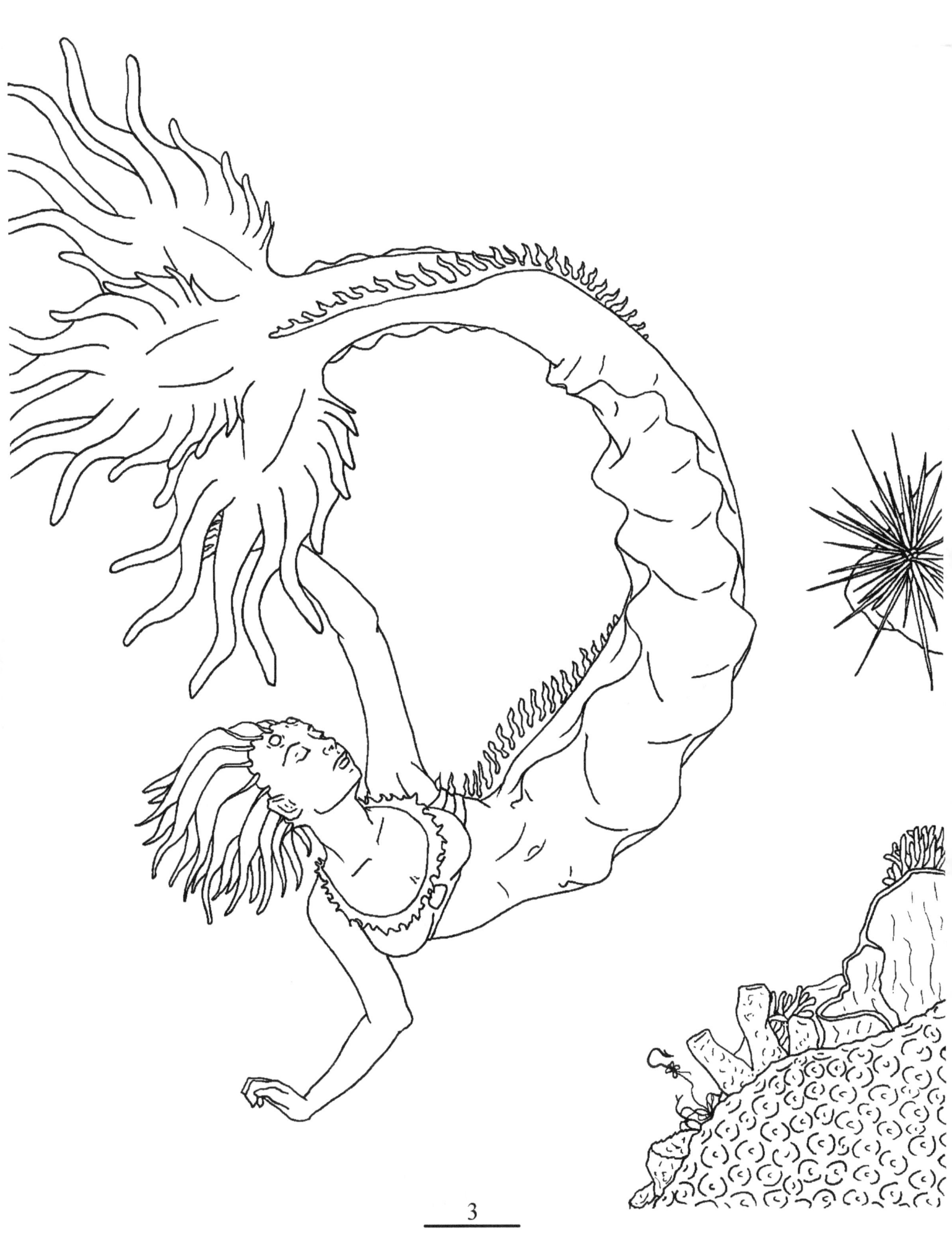

3

Illustration #3
NUDIBRANCH

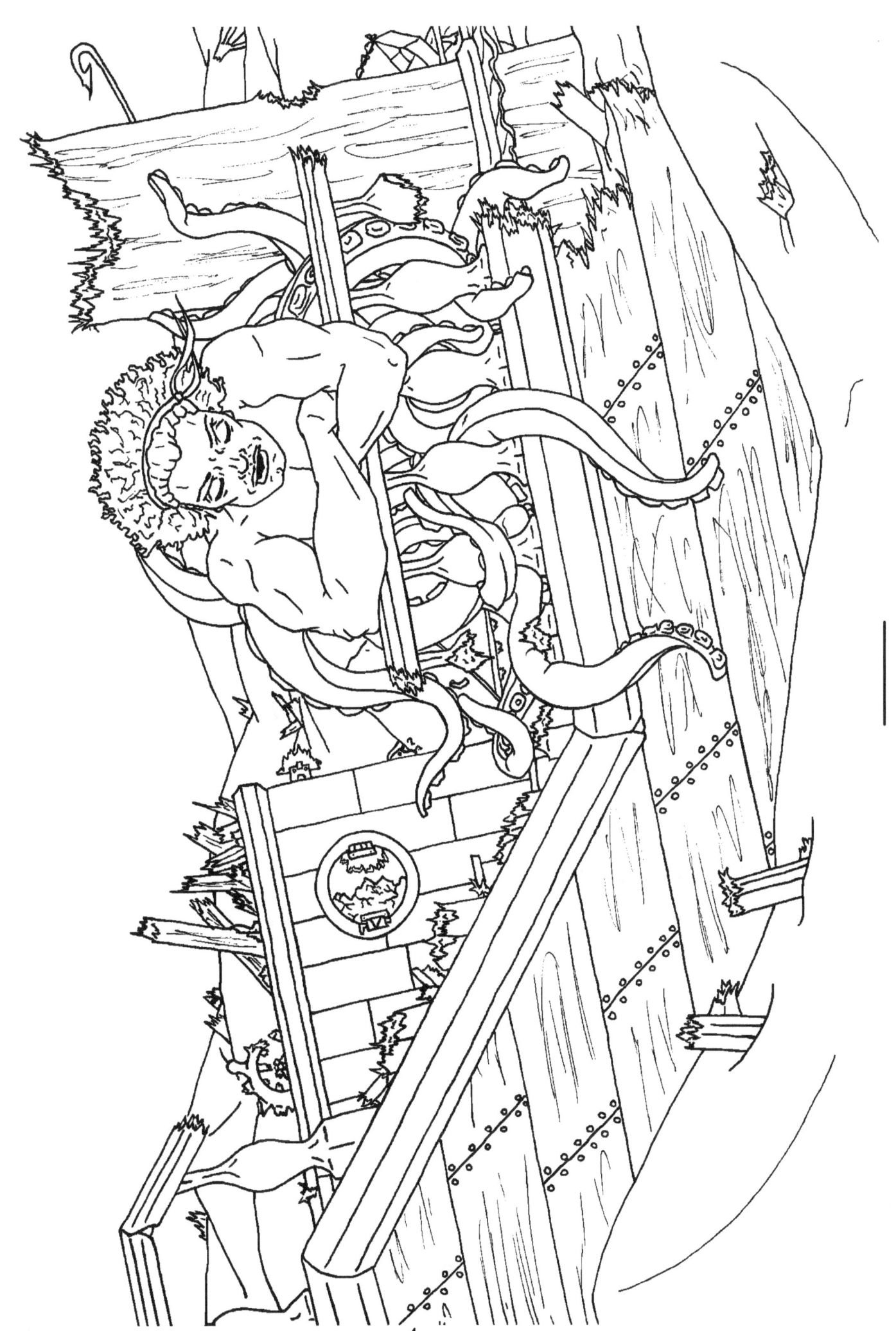

Illustration #4
OCEAN MASTER

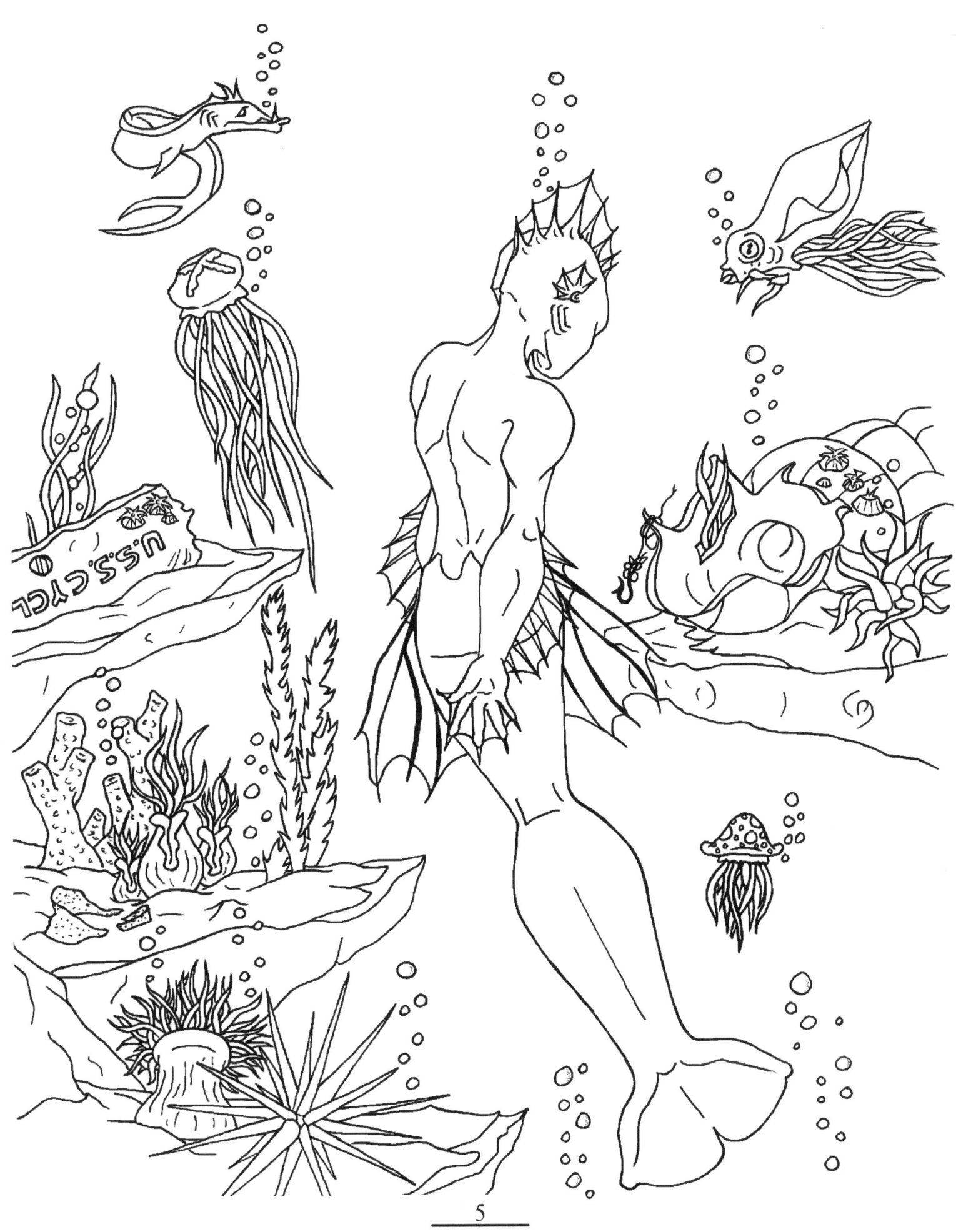

Illustration #5
TRIANGLE

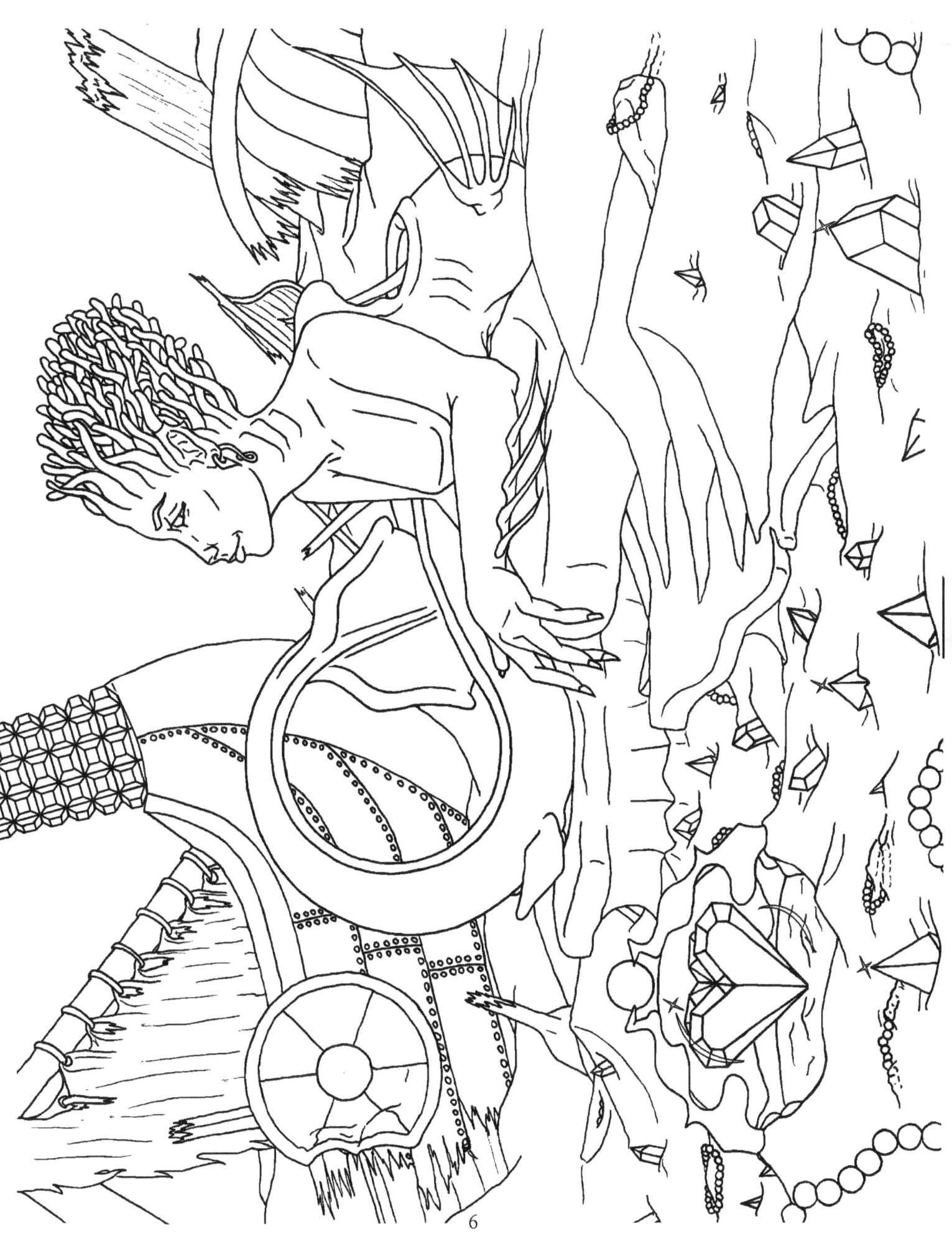

Illustration #6
SEA SPHINX

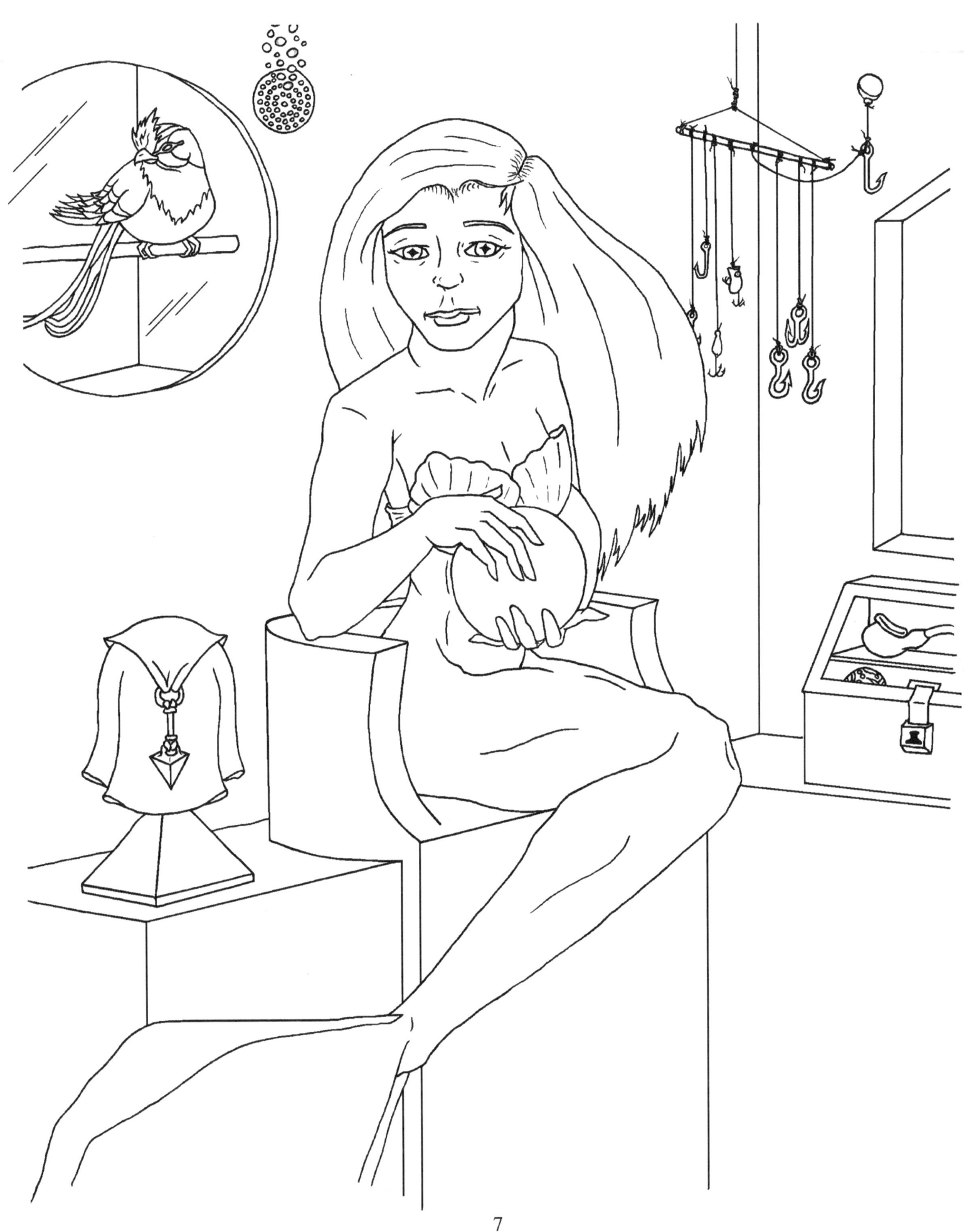

Illustration #7
TRINKET

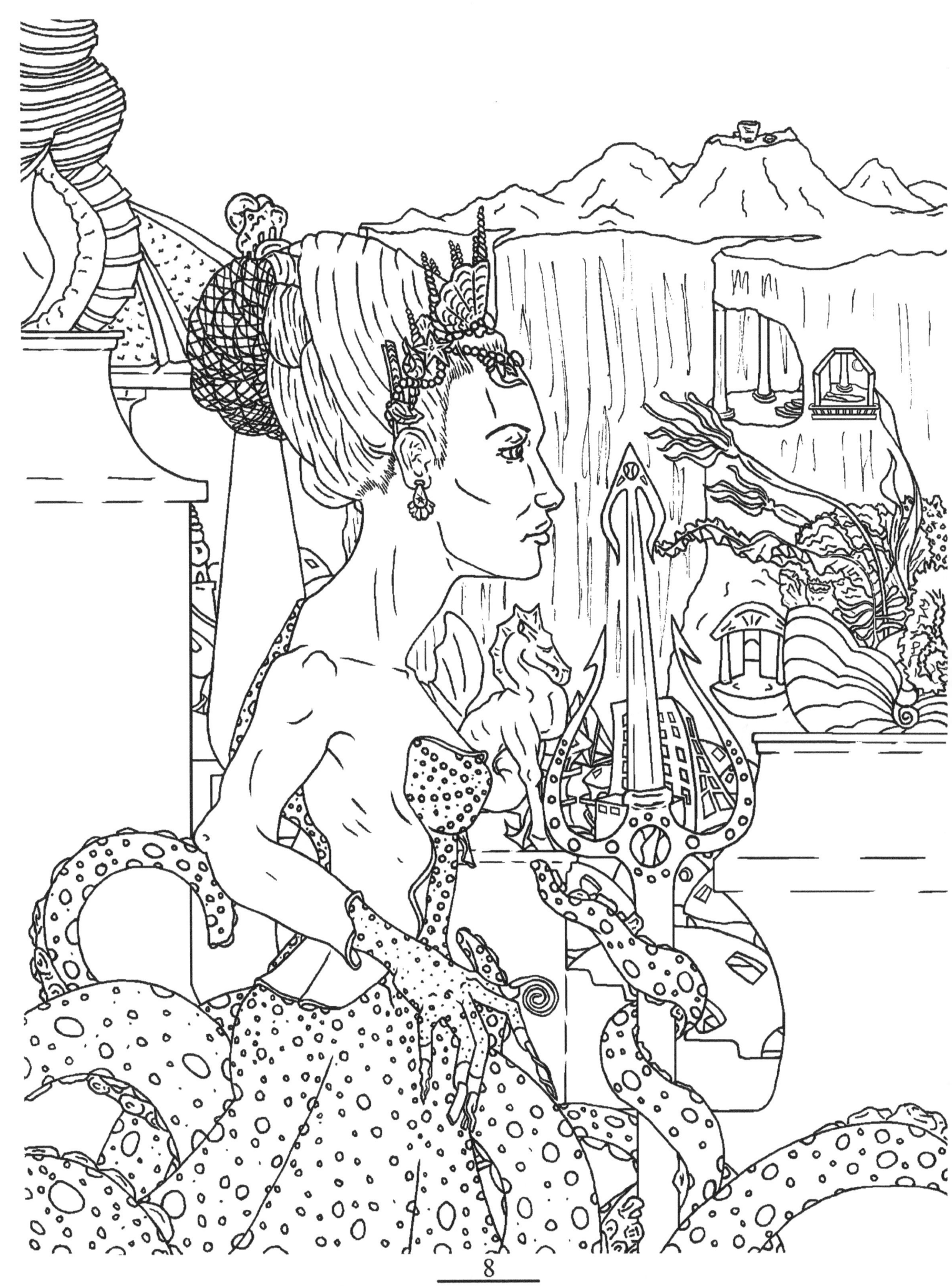

Illustration #8
AMPHITRITE

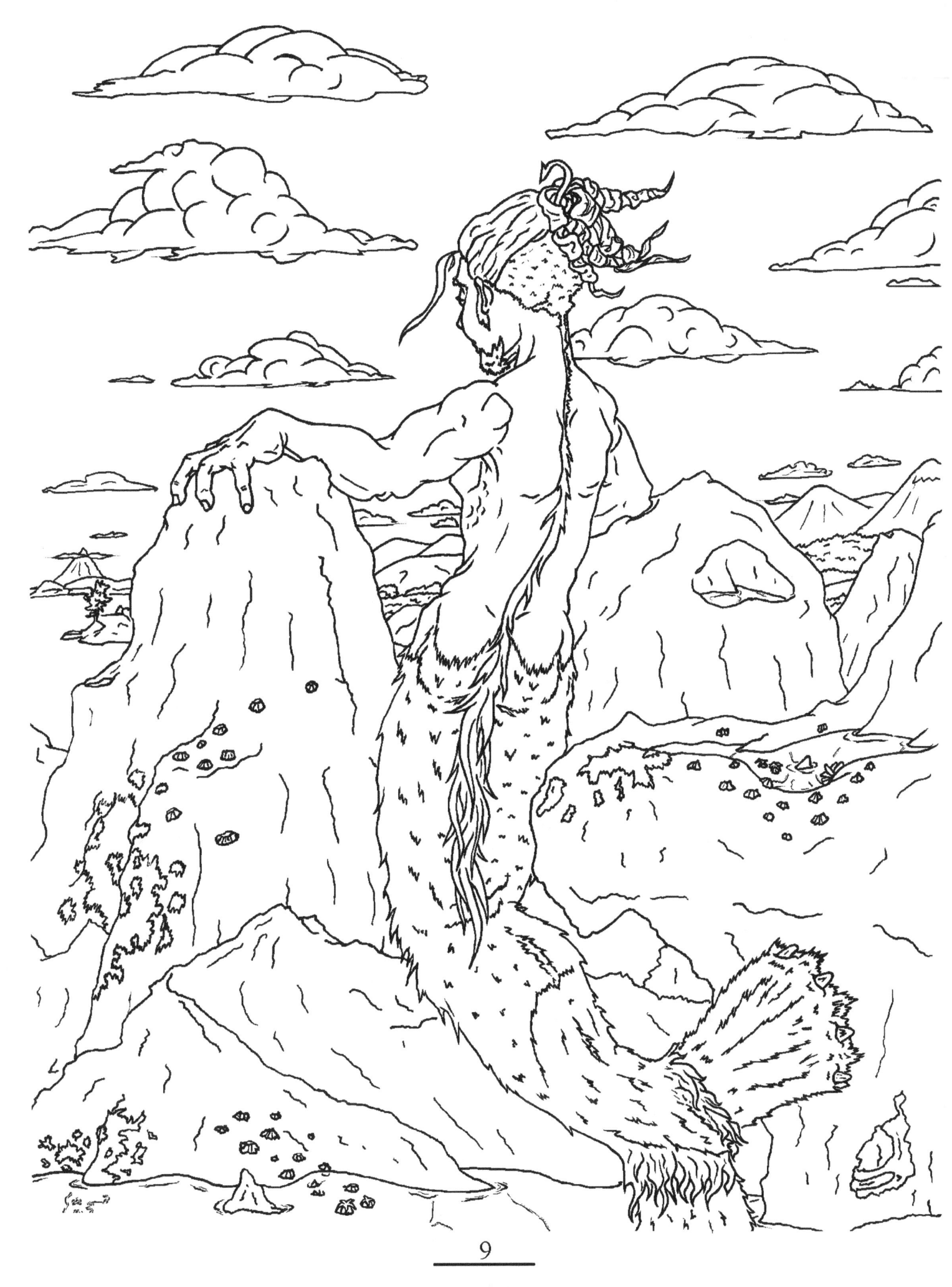

Illustration #9
HADRIAN

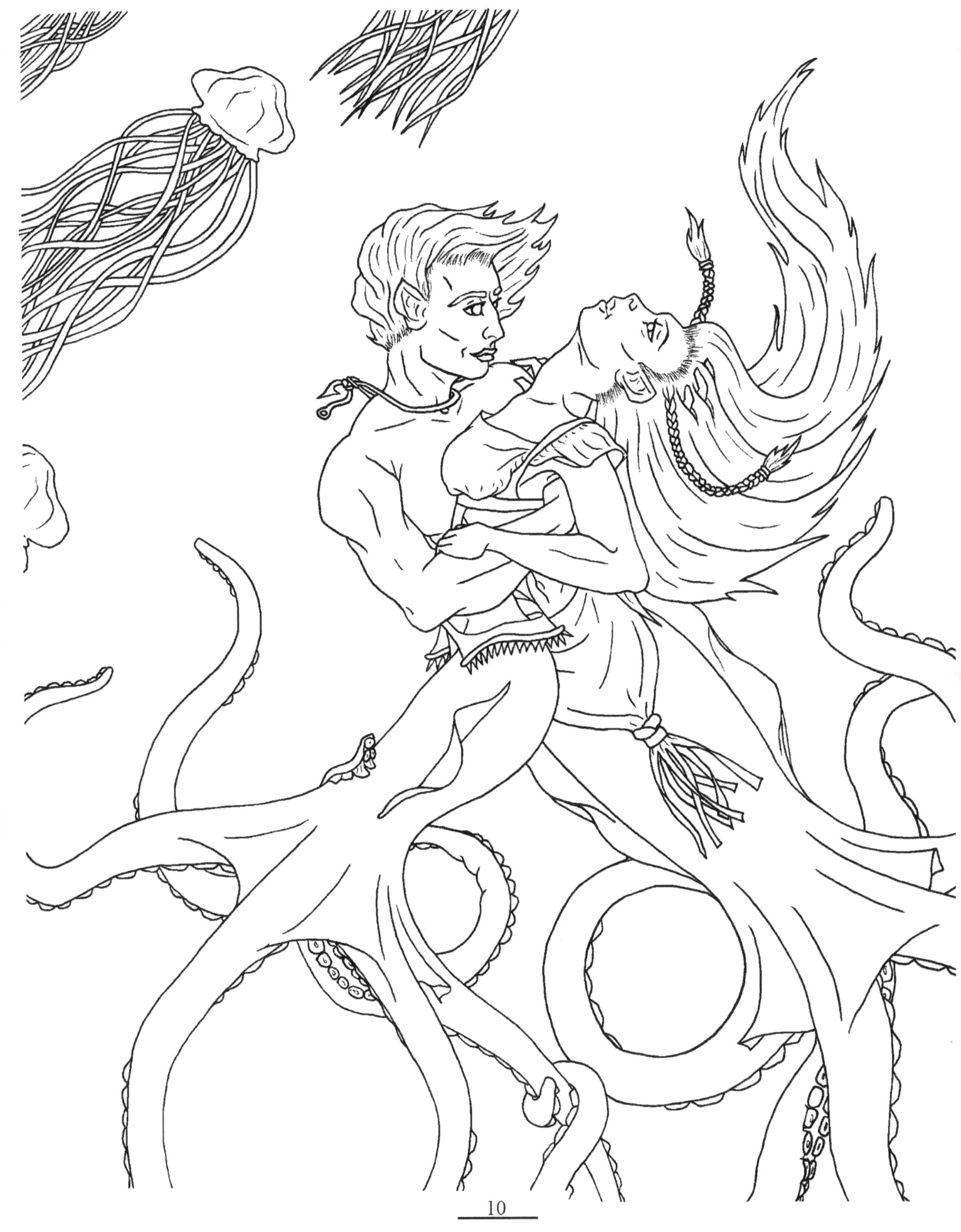

Illustration #10
DANCERS OF THE DEEP

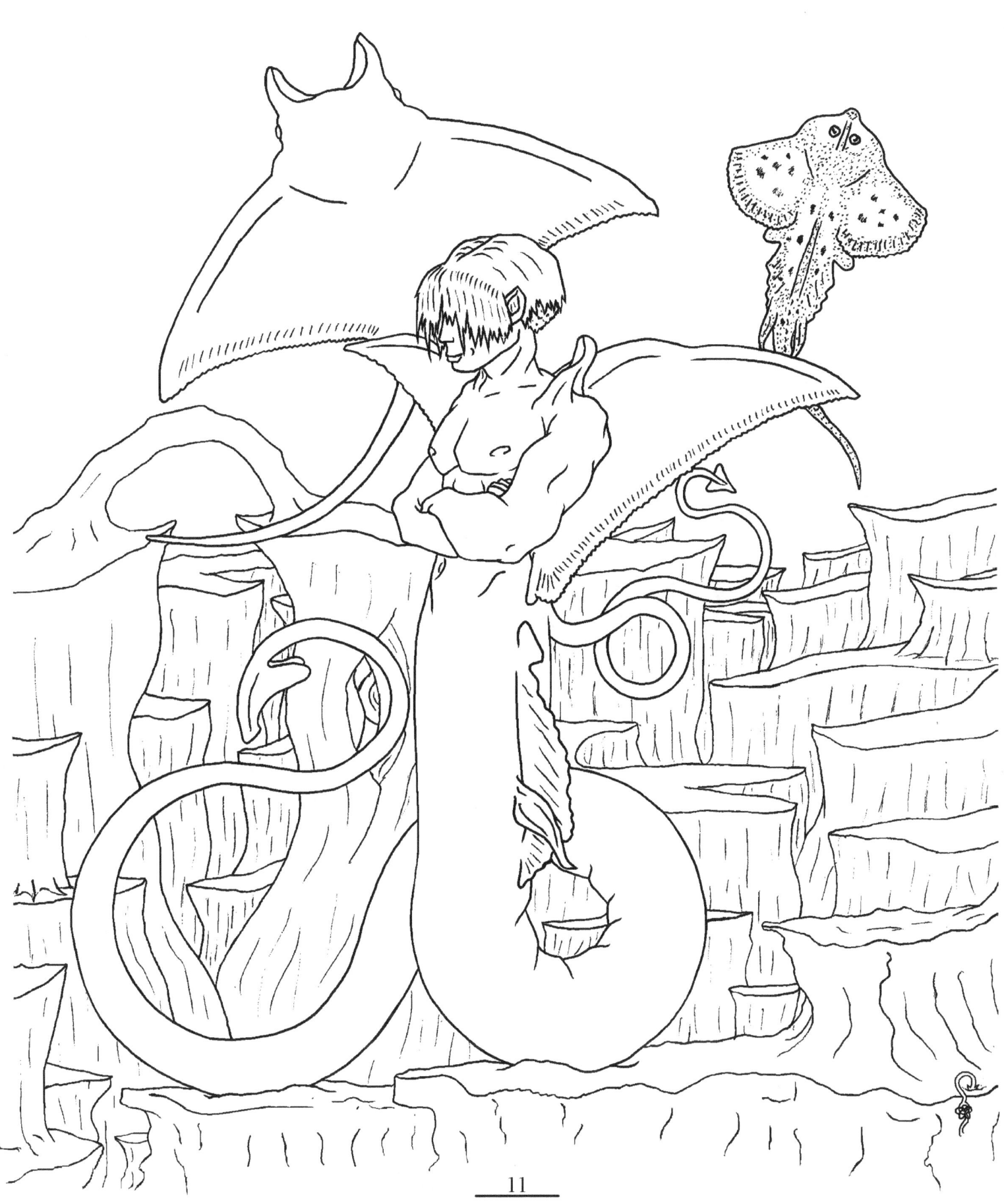

Illustration #11
CASPIAN

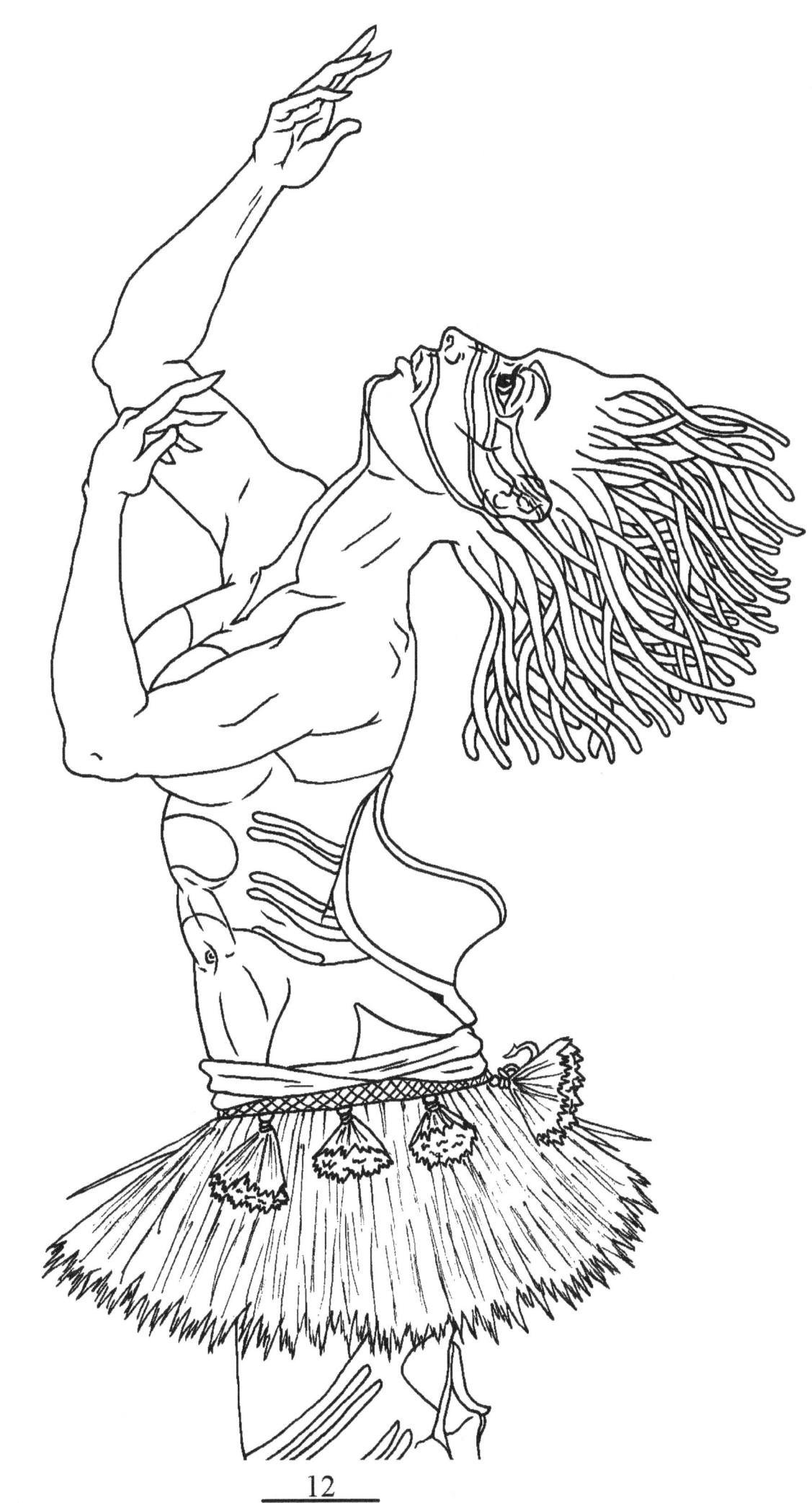

Illustration #12
HUMUHUMUNUKUNUKUAPUAA

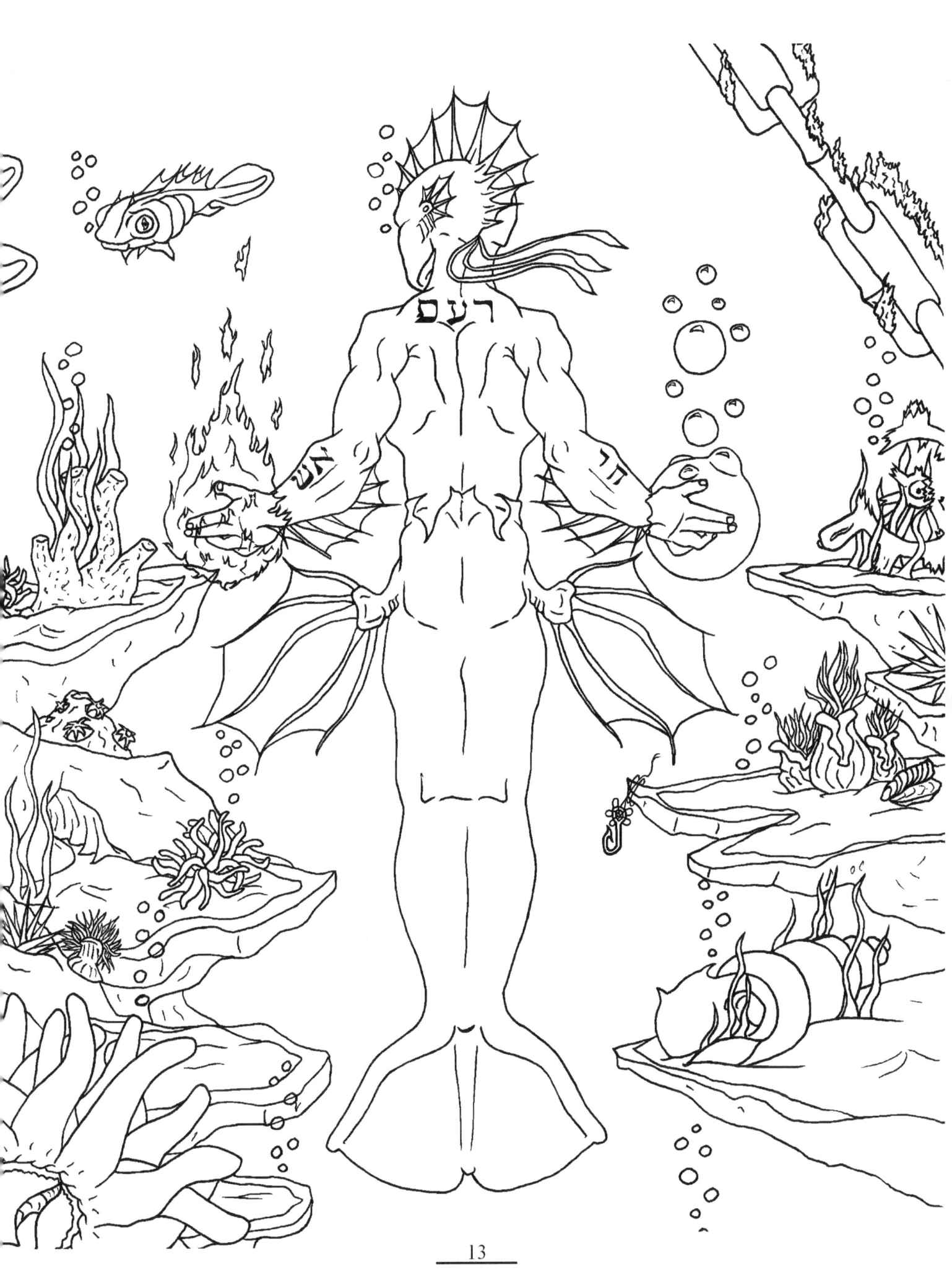

Illustration #13
FIRE THUNDER AND LIFE

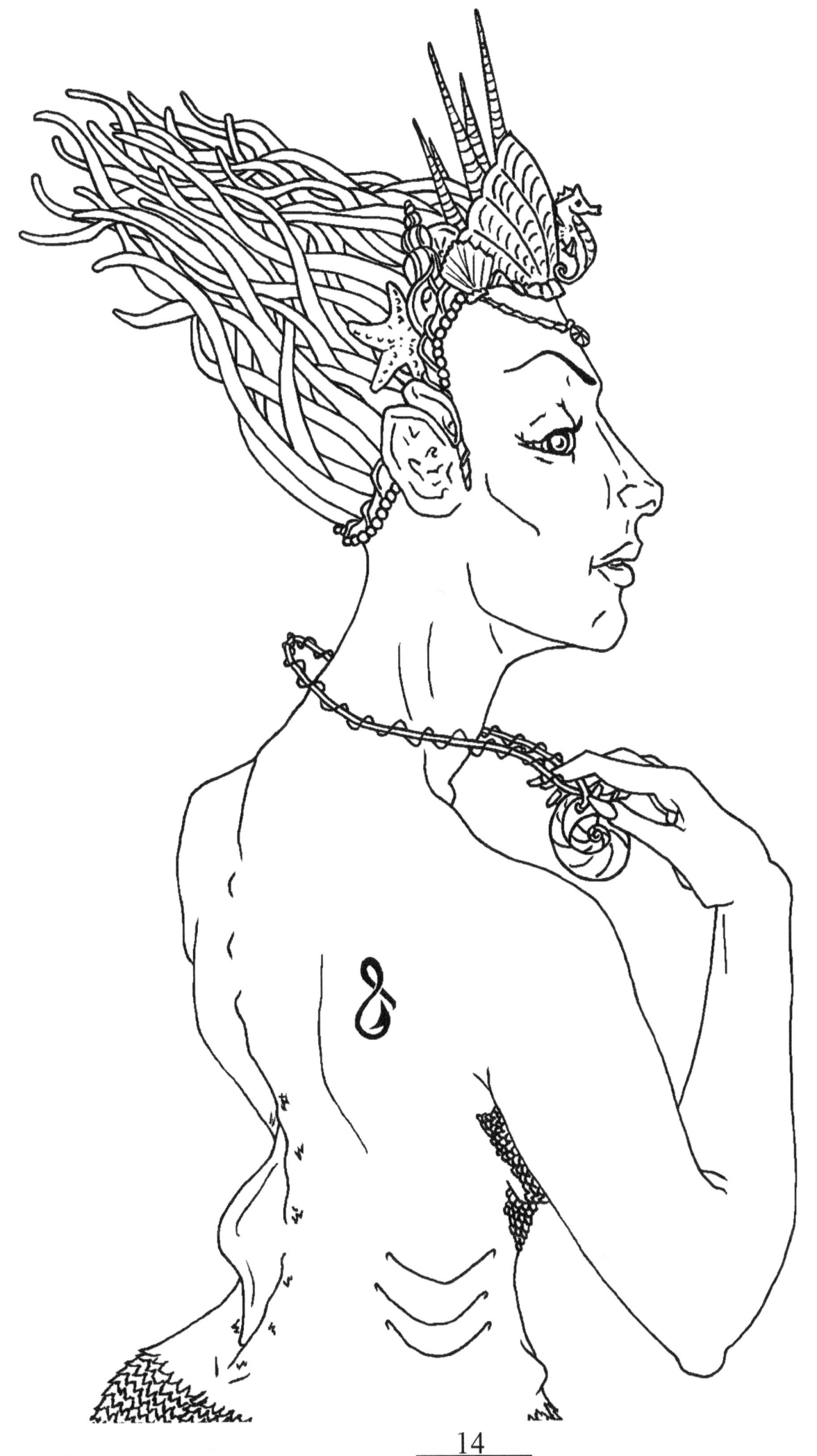

Illustration #14
PRINCESS

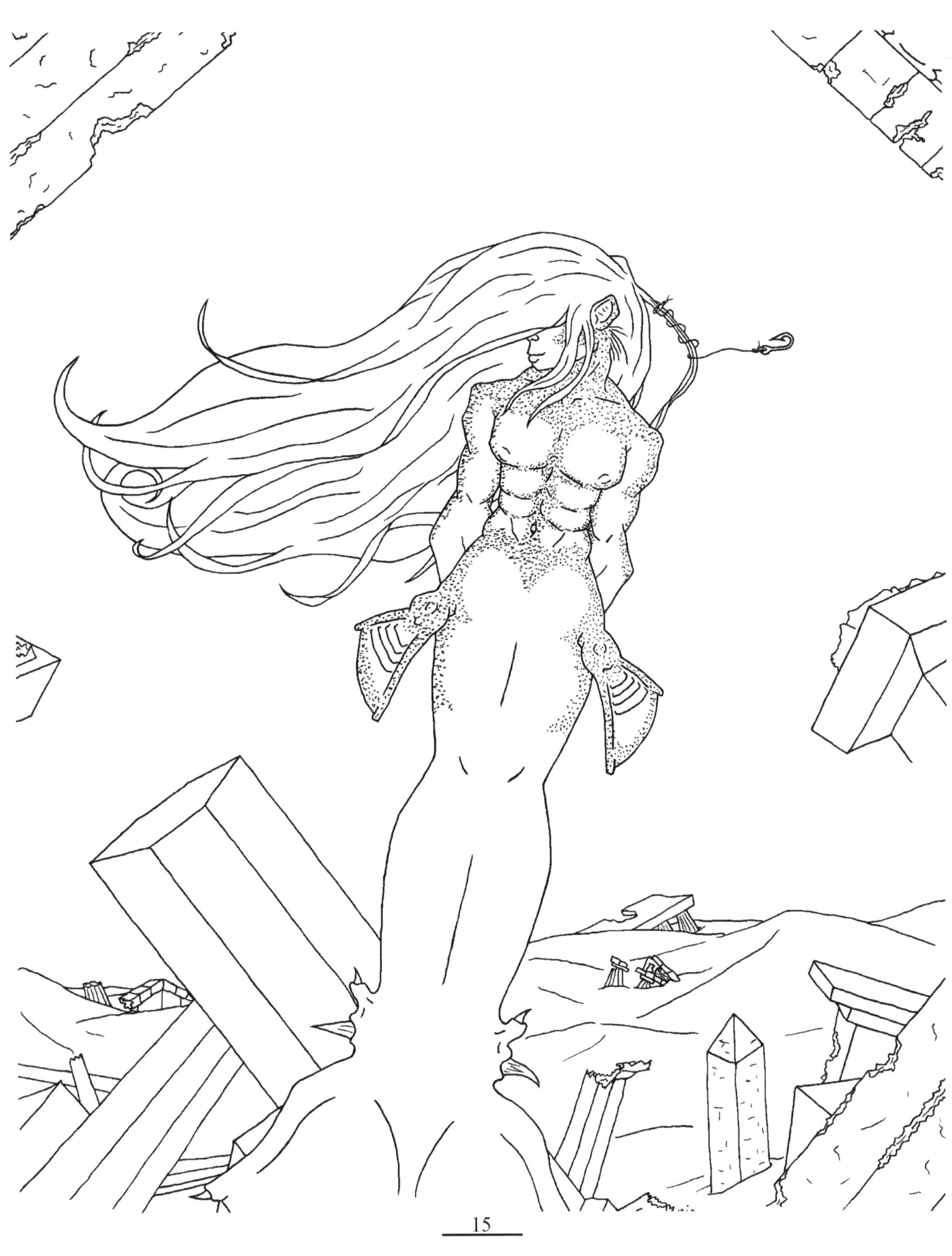

Illustration #15
ALEUTIAN

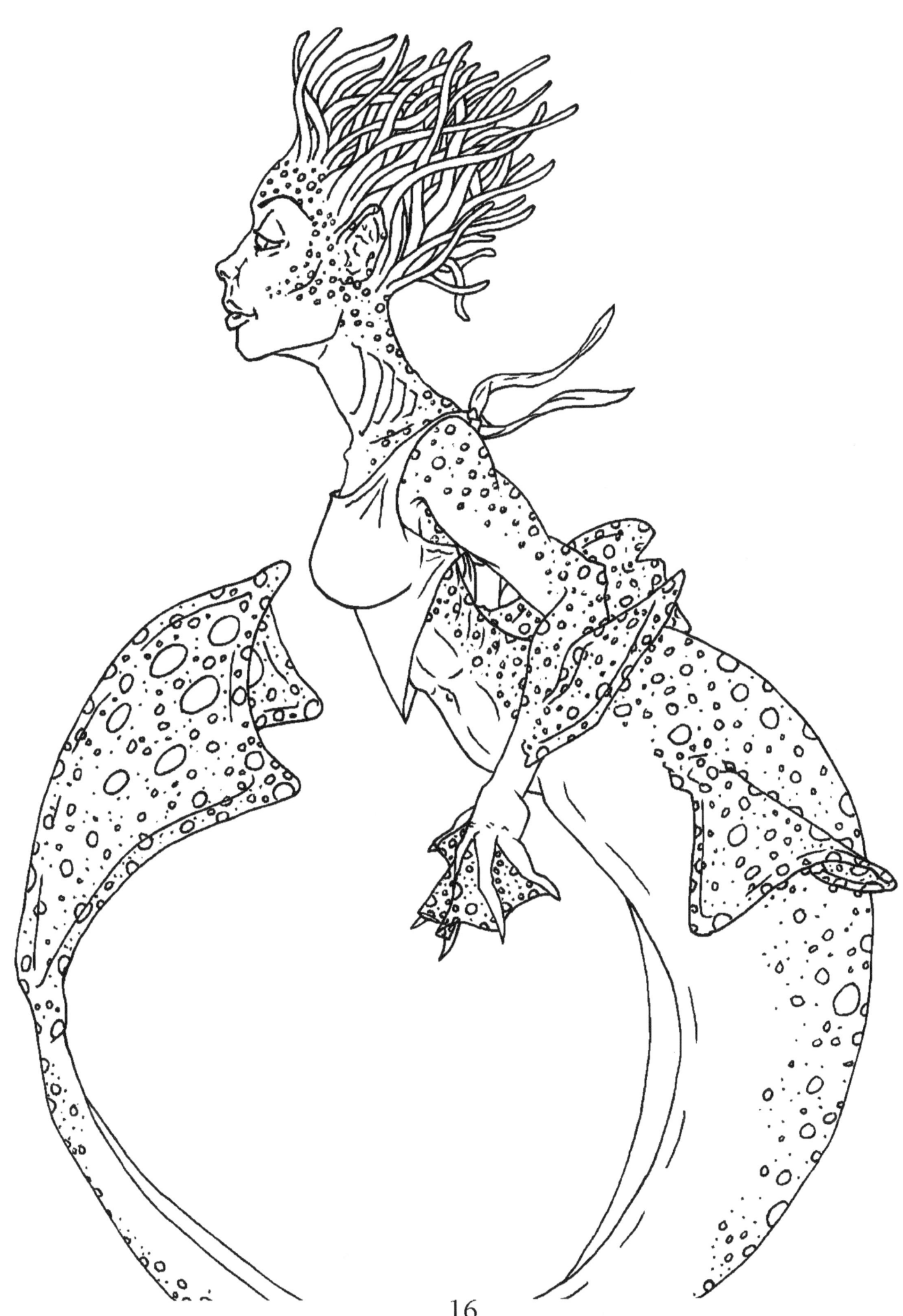

Illustration #16
FATHOM

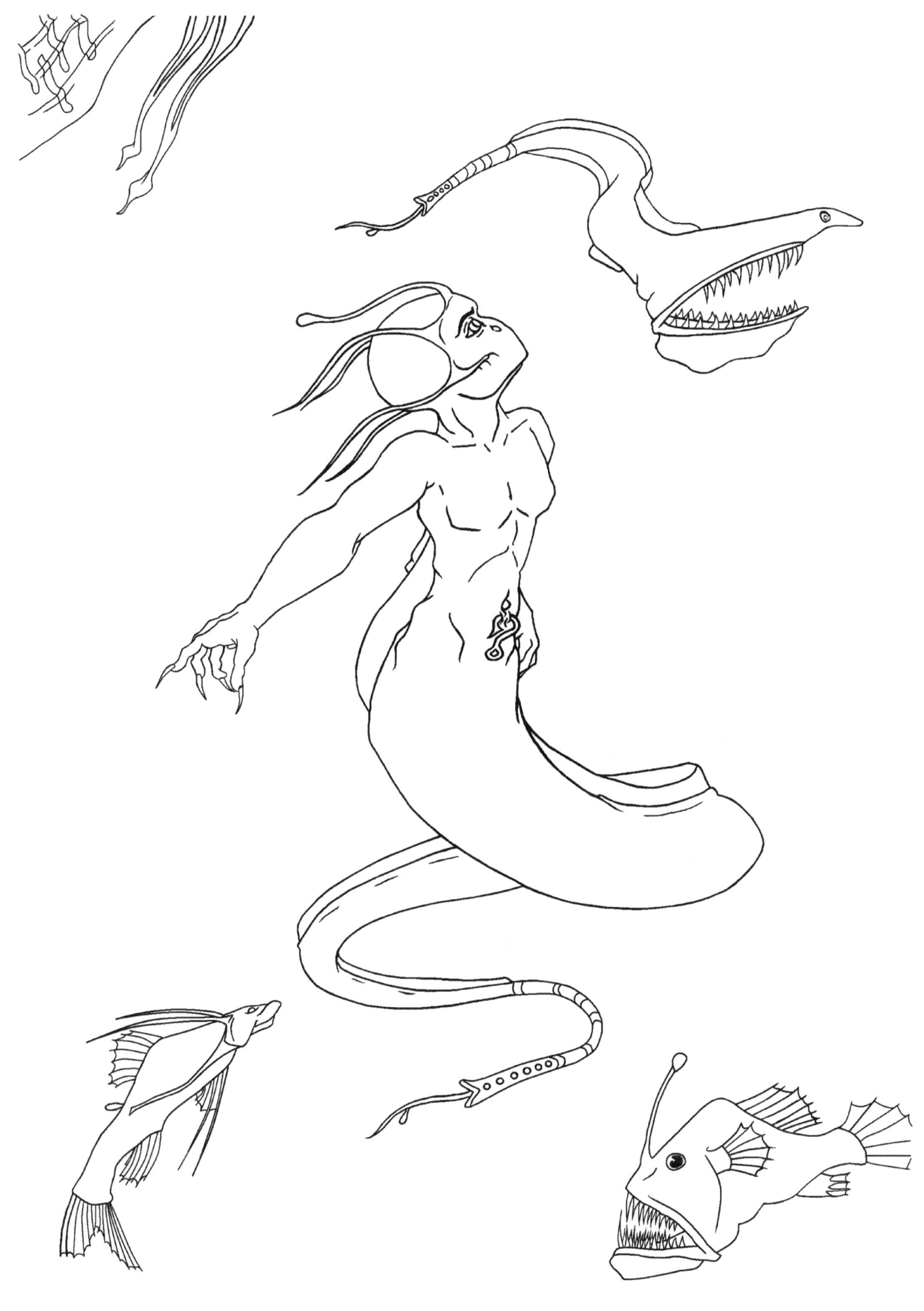

Illustration #17
FATHOM

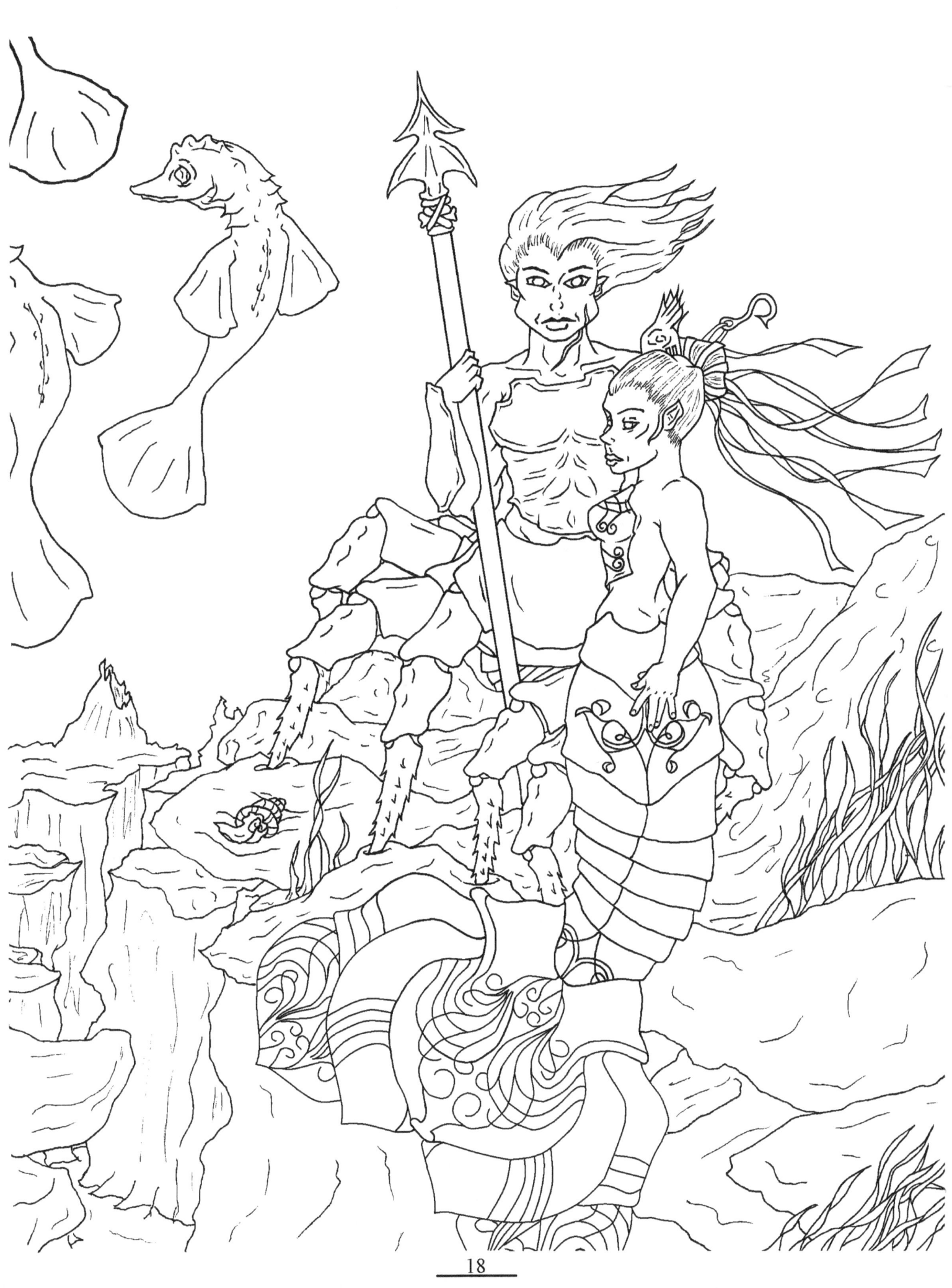

Illustration #18
WORDLESS LOVE

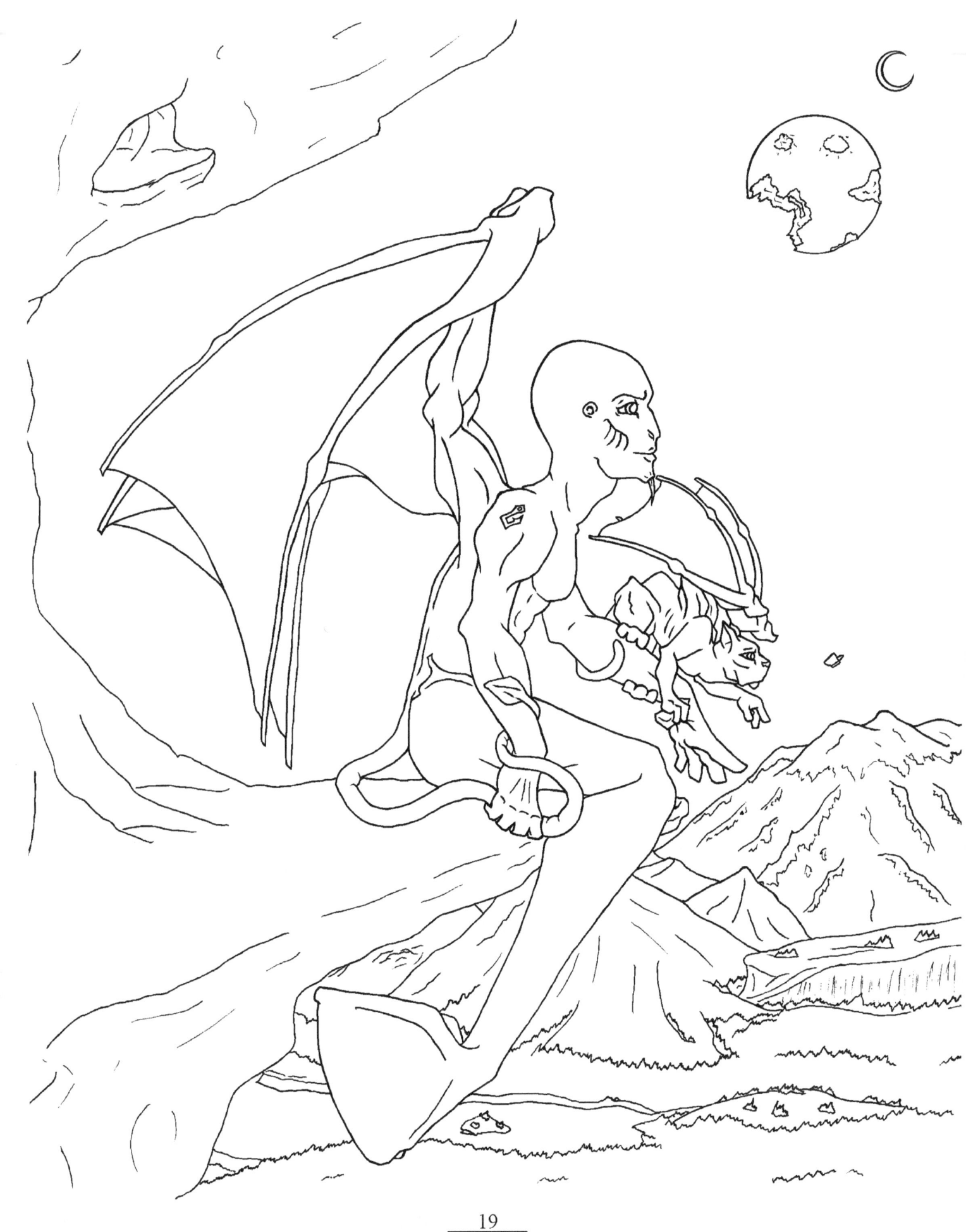

Illustration #19
TEMPEST

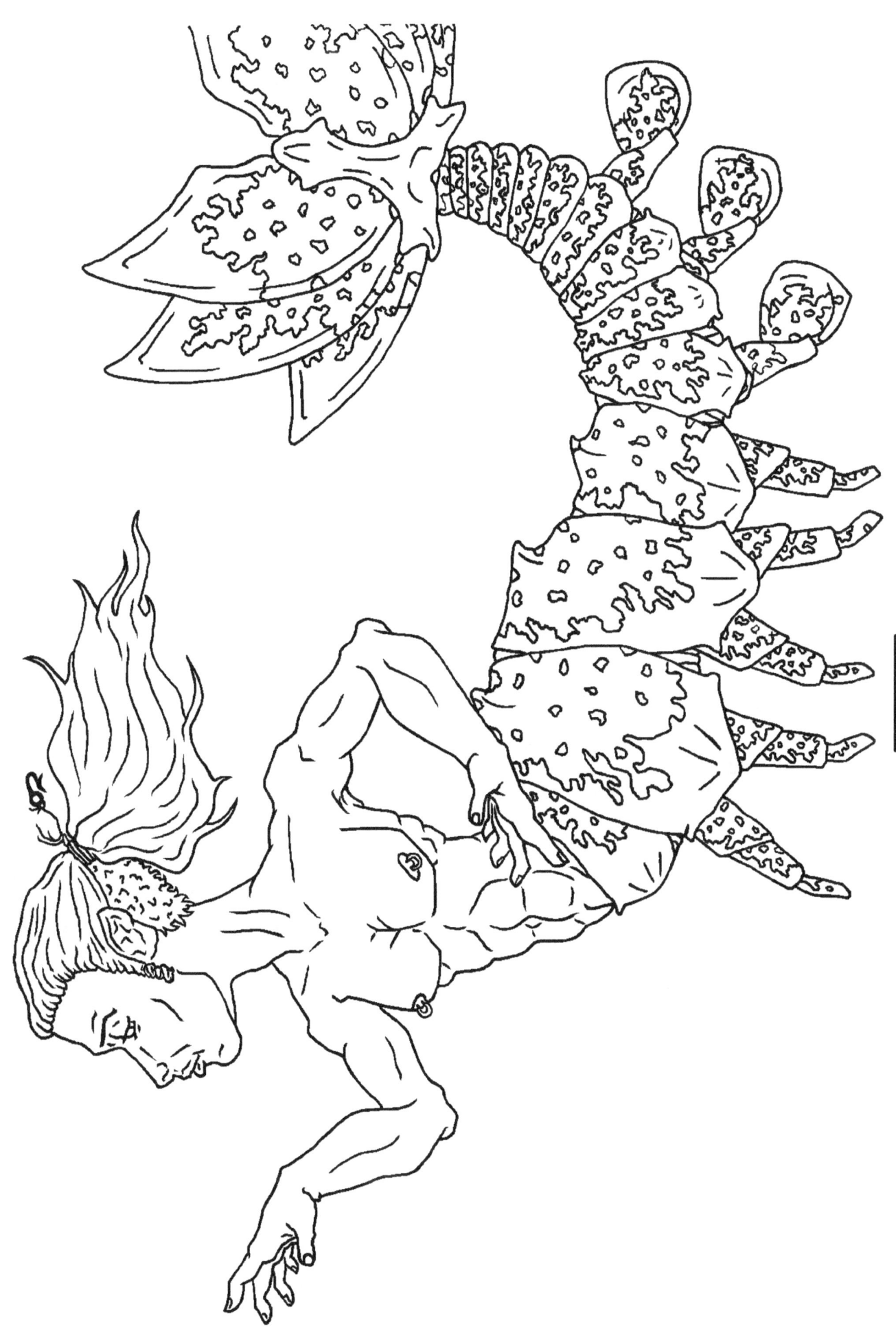

Illustration #20
KRILL

The Story and the "Story Behind" Each Drawing

#1. Sun Bathing: Peacefully resting on her enchanted ocean settee, she is dreaming of the fairy tales of old and the imaginary creatures she hopes are real and to someday meet. "Humans must lead exciting lives," she murmurs as she drifts off to sleep.

Technical details: One day I saw my sister napping in an arm chair and started to draw her. Before I was finished she woke up and went out to visit a friend. After setting the sketch aside for a week or so, I came back to it and her pose looked like a basking mermaid to me. At the time I drew this, my willows resembled Dr. Zues' trees.

#2. Sun Surfer: Perched as if ready to vault himself from the rock, Tide faces into a strong wind blowing in from the sea. Marveling at the unattainable sky and the beautiful clouds that roll across it, he never ceases to be awed by its apparent endlessness. Tide is amazed by the fascinating inventions that humans continue to make, bringing themselves ever closer to heights he could only dream of attaining.

Technical details: I drew this picture after I had bought an amazing anatomy reference book and wanted to use a pose in it as a merman. Wanting to convey strength in his pose, I placed him out of the water where his weight would not be supported by the current.

#3. Nudibranch: Allowing the gentle current to pull her about, Pelagic twirls gracefully in time to the distant sound of the whales' mournful song. It's a long way to the bottom of this canyon, plenty of time for her to revel in her soft, free falling dance.

Technical details: While on vacation in September, I was walking along the beach early one morning. This was after a storm and I was in hopes of finding intriguing shells. Strung along the beach were these things that looked like smooth river rocks and when I picked one up I was surprised to find it was soft like a slug (without the slime). I learned they were a salt water creature called a Nudibranch. Looking these up online, I discovered that these strange sea creatures look plain and unremarkable when disturbed or threatened. Undisturbed they extend "horns" tentacles and lacy fins, changing to vibrant colors. There are more varieties of these marvelous creatures than you would believe. My favorite would have to be the paladin which I based this mermaid on. The creatures in the bottom right corner are also real; corals, anemones and a sea urchin.

#4. Ocean Master: Resting tranquilly amidst the quiet groaning of rotting masts and timbers, this solitary being can pose motionless for hours-on-end, content to while away the days, to spend the dark ocean nights haunting the jagged rocks, watching for the next doomed ship to crash and sink to join the rest of his mangled trophies.

Technical details: I just started drawing and this picture came from the scenes in my mind. From somewhere this guy began to form. I felt that an octopus would be more of a solitary creature keeping to places with plenty of dark nooks to lurk in. Nothing seamed to suit better than a sunken ship with unnumbered decks hidden beneath the sandy ocean floor. I needed to see someone with a very muscular build to draw his arms so I used a friend I was doing a portrait of at the time. He lifts weights so I was able to make the rendering more accurate.

#5. Triangle: Silently patrolling her elusive domain, Sentinel protects the strange creatures within the triangle. Its secrets must be kept for the safety of those within as well as the strange beings of the outside world. So many of those creature's vessels have already entered her world, never to return.

Technical details: While researching for another drawing I was working on, I came across an article on the Bermuda (or Devil's) Triangle. That project forgotten for the moment, I proceeded to delve into the mysteries of this sinister place. I couldn't find much on the Triangle in my set of outdated encyclopedias other than the fact that an eerie amount of planes and ships have passed thru it, never to be seen or heard of again. The strangest thing is that many planes and ships do manage to cross through unharmed every day! There is no pattern to the disappearances. The first U.S. Ship to be recorded as missing was the U.S.S. Cyclops. On December 5, 1945, an entire squadron of U.S. bombers and a sea plane vanished while searching for the Cyclops*. You'll notice a piece of the ship to the left. This mermaid has interesting fins everywhere. All the other creatures are real except for the squid like one in the upper right corner and the clams with anemone arms. I wanted to put some unrecognizable creatures in with the real ones so I took a little artistic license.

#6. Sea Sphinx: Contentedly at home among the vast graveyard of ships, this ocean sphinx gazes proudly out at her field of plunder; ancient treasures gleaned and collected from many centuries of conquered pirates and Vikings, never suspecting this beautiful siren to be as ruthless a treasure seeker as themselves

Technical details: This rendering was actually the one that started them all. I was sitting in a lounge chair on the beach with the sea air curling the corner of my paper as I sketched out the mermaid in this scene. The ship prow is modeled after a Viking ship and the mermaids pose reminded me of the Egyptian Sphinx. My mom thinks the sphinx looks like Whitney Houston. All the gems in the foreground are purely inventions of my imagination.

#7. Trinket: Forever intrigued by the mysterious creatures called "humans", Sar-Tah takes every opportunity to observe these strange beings. Her growing collection of trinkets consists entirely of things created or valued by man.

Technical details: My sister requested this one specifically. She wanted me to do a nod to Ariel of the Little Mermaid "You can't do a book of mermaids without her!" Notice the "snarf-blat" in the box. Lovers of Disney's Ariel will know what it is.

#8. Amphitrite: Wife to Poseidon and Queen of all earths' waters, Amphitrite glides elegantly through the marble hallways of her vast palace at the oceans capital. Both loved and revered by her subjects, no problem is too small for this majestic queen's personal attention.

Technical details: According to Greek and Roman mythology Amphitrite was the god Poseidon's wife and the queen of the sea. In ancient paintings and sculptures she is depicted with a pair of crab claws on her forehead. If you look closely you'll notice that her human looking skin is actually over the octopus flesh. The horse like statue in the background is called a Hippocampus. This drawing is full of eye candy and was actually drawn and flipped left to right. My editor felt it looked better that way, you decide. The plants and sponges in the shell are all real kinds you could find in the ocean. The shell is based on the nautili's shell and all of the crown shells are of actual ones I found on the beach.

#9. Hadrian: Casually stationed on the outward jutting rocks observing both land and sea, Hadrian belongs in both. Possessing the rare ability to shed his fir and take on the appearance of a human, the beach is not the boundary marker for him that it is for his fellow sea dwellers.

Technical details: I wanted to do a merman based on a Selky. Selky are mer-people that shed the skin and form of a seal and turn into a human. Hadrian is a merman that is half seal instead of half fish. He is surrounded by barnacle encrusted land, showing that it is often completely submerged in water. You can see through the shallow water in some areas.

#10. Dancers of the Deep: Two hearts beat in time as the passionate dance of union is performed, displaying there love for one another in a timeless ritual for all to see, eternally joining in soul; committing to each other for all ages.

Technical details: I decided that with all of the single characters I'd drawn I needed to put a few couples in. These two are squid-people (they have six tentacles not eight which octopus have.) They are joined in their dance by swift moving jellyfish.

#11. Caspian: Master of skates and rays, Caspian possesses an air of confidence while guarding his vast domain. Both powerful and graceful in his movements, few come close to matching him in speed and agility.

Technical details: After using a friend's portrait for the arms on Ocean Master, it worked well to base this one loosely on his brother. I am really pleased with how his expression came out; it looks so cocky and self assured. Caspian is a mer-person but his make up is a combination of skates and rays as well.

#12. Humuhumunukunukuapuaa: Puaa joyfully dances to the drum like beats of the island surf displaying to the chance observer her vibrant colors that mimic the tropical fish she is named for.

Technical details: I actually went thru a lot of fish pictures looking for one that had a decidedly Hawaiian feel to it. I wanted to depict a mermaid of the tropics, since the others so far could belong in any clime. The markings on her are just like the real fish. Look closely at the intricate pattern and flow of the anemone like hair, it's very complex.

#13. Fire, Thunder and Life: Wielding the ability to create fire with his left hand and healing with his right, Tetris stands watch over his uncharted island, providing warmth and healing for any unfortunate to wash up in his lagoon. Possessing a rumbling voice of thunder, many find his kindness a strange contrast to his hard appearance.

Technical details: After doing Triangle I decided to do a complimentary one with a merman.
I like the idea of fire and air co-existing within one creature and under his control. The words on his body are either there by choice (tattoos) or possibly there from his creation, I'll leave it up to you. The wording is actual Hebrew I researched in a concordance. I hope it's correct. I put the anemone clams from Triangle in here along with some armored fish I came up with. Everything else is based on real creatures.

#14. Princess: Often coming across as vain, this aquatic heiress is thought to spend hours admiring her self in reflective surfaces. Though she can seem distracted at times and does tend to stare into reflections, it is actually the people around her she is watching so intently.

Technical details: One day I was waiting in the car while my mom went into Wal-Mart I just started sketching this shell crown and liked it so much I made into a finished drawing. One line led to another and wound up being this mermaid portrait. She wears a shell necklace and, like another mermaid I've seen, there may be a voice inside. Even I don't know.

#15. Aleutian: The last of his kind, he prowls the once busy streets of Tyre. The true origin of the fabled Atlantis, the once proud city, now crumbles far beneath the arctic waters. Agelessly guarding the secrets buried far beneath the sand, he awaits one worthy of continuing his long kept vigil.

Technical details: I had just finished reading a book by Clive Custler called "Atlantis Found" and decided to do this depiction of an Atlantian dweller. I also wanted to do a merman with very long hair because my sister likes the flowing locks I put on all of my male elves. He's a pretty buff fellow, floating about in the wreckage of the doomed city.

#16. Plecko: Always the playful type, Plecko is able to find amusement in everything. From chasing schools of the speckled bottom feeders she resembles to swimming in circles, you will always find her laughing at life's simple joys.

Technical details: My Dad has this big fifty five gallon aquarium and he loves getting fish for it (although he doesn't have the best of luck with them.). One of his favorite kinds of fish is the plecostomus. This little girl was inspired by them. She has an incredibly small waist compared to her hips and some fantastic hair tentacles. Her skin markings are just like the real fish she is modeled after. Dad was kind of bummed out when two of these algae eaters he had just bought died, so I drew this in memory of them. For Phyx and Chypss (Fish and Chips)

#17. Fathom: Living in the lowest point of the deepest chasm, far beyond the sun's reach, Fathom sees the nightmarish creatures around him as mere pets at best and only something to avoid at worst. In a world where every creature glows with an ethereal light no matter how thick the dark, he is never without a galaxy of stars.

Technical details: The creatures swimming along side Fathom are actually real deep sea creatures. In the bottom right corner is a deep-sea angler (3in long). Bottom left is a tripod fish (10in long). Top right is Umbrella mouth gulper eel (2ft long). Top left is the underside of an Oarfish (35ft long). I chose to depict each fish in proportion to suit my own taste. Fathom is actually a combination of all together.

#18. Wordless Love: In spite of the fact that one was born mute and the other's voice was taken in battle, there love for each other hardly goes unspoken. Expressed in there inseparable hearts, their souls speak volumes!

Technical details: My crustacean couple. Not all mer-people are human sized. These little wonders are about the size of the real thing. Tiny people - big love.

#19. Tempest: Belonging to both sea and sky, Tempest enjoys a freedom few mere people dare even dream of. Conceived when lightening kissed the sea, he fears neither and welds both. His only companion is a small draken named Phyx (pronounced fish).

Technical details: I had just figured out how to do these cool wings and decided that a flying merman would be a neat addition to my coloring book. Kill the butterfly! (Inside joke) He lives on another world where he can swim or fly at his discretion. His draken buddy resembles my cat. You'll notice the double moon sky that orbits his world.

#20. Krill: Although his stature is small Krill's heart is big. Just as formidable in a battle of wits as he is in combat, his eagerness and swift ferocity far outweigh whatever he may lack in size. Whether it is defending his friends or lifting there spirits with wry remarks, Krill is always ready to lend a tiny hand.

Technical details: After doing the crustacean couple I felt that I should put one in as a single. Krill is designed after a lobster and a shrimp. He's also a pretty small guy. I'm only 5 feet 1 inch tall so us little people gotta' stick together. Isn't he a pretty exotic chap with his body piercings?

(Note: a black bar at the bottom of each picture indicates its proper orientation.)

*Footnote #5: World Book Encyclopedia 1993, page 269

Hidden Hook Locations.

1. Bottom right of her island.
2. His chest piercing.
3. In the brain coral.
4. In the upper right corner of the picture.
5. Near Sentinel's right elbow.
6. In her left earlobe.
7. Floating from the mobile.
8. Her trident.
9. In his hair.
10. His necklace.
11. The shape of his tail point.
12. Behind the back skirt tassel.
13. Hanging under his right hip fin.
14. The birthmark on her right shoulder.
15. Wrapped around a strand of his hair.
16. Plecko *is* the hook!
17. In his navel piercing.
18. Floating from her hair.
19. His shoulder tattoo.
20. Bound in his hair wrap.

Hidden Cross Locations.

1. In the tip of hair behind her back.
2. His left arm fin.
3. Right of the hook near the third pipe plant.
4. On the stump in the left bottom corner.
5. In the left sea sponge plant on the left.
6. In the sixth opening for a ring in the sail.
7. Her left hand.
8. On her body above her wrist.
9. At his knees.
10. Her sleeve hem.
11. In his hair near his jaw.
12. On the third skirt tassel.
13. In the flame point.
14. On her spine.
15. Under his ear.
16. Under her arm.
17. In the eye of the creature in the top right corner.
18. In the blade of sea grass in the lower right side.
19. On the moon.
20. On the third leg plus a *bonus* one nearby.
 (Top of the next to last leg paddle)

Create Your Own Sea Fantasy

Create Your Own Sea Fantasy

Create Your Own Sea Fantasy

Create Your Own Sea Fantasy

Create Your Own Sea Fantasy

Create Your Own Sea Fantasy

www.ingramcontent.com/pod-product-compliance
Lightning Source LLC
Chambersburg PA
CBHW080838170526
45158CB00009B/2585